RULE THE WORLD

2020 PLANNER

paige tate
& CO.

Published by Paige Tate & Co.
Paige Tate & Co. is an imprint of Blue Star Press
PO Box 8835, Bend, OR 97708
contact@paigetate.com
www.paigetate.com

ISBN 9-781944515928

Printed in China

10 9 8 7 6 5 4 3 2 1

JANUARY – DECEMBER
2020

This planner belongs to:

WELCOME TO YOUR

RULE THE WORLD

PLANNER

For creatives, entrepreneurs, influencers, and anyone with superwoman goals and aspirations, the RULE THE WORLD Planner will help you tackle it all: track your to-dos, chase your dreams, and achieve your goals like a boss!

ABOUT THE ARTISTS

The Paige Tate & Co. Author Community brings together passionate and talented artists, makers, and business owners. Your 2020 Rule the World Planner features the work of these artists:

ILANA GRIFFO

www.ilanagriffo.com | @ilanagriffo

KORIE HEROLD

www.theweekendtype.com | @theweekendtype

ALLI KOCH

www.allikdesign.com | @allikdesign

TABITHA PAIGE

www.foxhollowstudios.com / @foxhollowstudios

SHANNON ROBERTS

Etsy - TheWhiteLime | @shannonroberts19

SARAH SIMON

www.themintgardener.com | @themintgardener

MONTHLY FEATURES:

LAST MONTH'S HIGH FIVES

Begin each month with a quick reflection on last month.
What progress did you make or what goals did you accomplish?

THIS MONTH'S GOALS

Think about the month ahead. What are your top priorities?
What do you hope to accomplish? Write it down!

WHAT'S THE MOTIVATION?

WHY are these goals important to you? What is driving you?
Here's your chance to check yourself and make sure you're working
toward something that is truly meaningful to YOU.

STEPS TO GET THERE

You need a plan for action!
Identify the concrete steps you need to take to accomplish your goals this month.

MONTHLY BUDGET TRACKER & MONTHLY SPENDING LOG

Empower yourself by taking control of your finances!
Use these pages to track your recurring monthly expenses and spending.

WEEKLY FEATURES:

TOP 5 PRIORITIES & TO-DO

Use this space to jot your weekly tasks to keep on top of
your responsibilities and commitments.

HABIT TRACKER

Whether you're working toward a fitness goal, a professional goal, or even something
as simple as drinking enough water or getting enough rest, use this space to track
your weekly progress.

DOTS & NOTES

The last two pages in each month are for doodling, brainstorming, or anything
else that fuels your creativity or productivity!

2020 AT A GLANCE

JANUARY

S	M	T	W	Th	F	S
			1	2	3	4
5	6	7	8	9	10	11
12	13	14	15	16	17	18
19	20	21	22	23	24	25
26	27	28	29	30	31	

FEBRUARY

S	M	T	W	Th	F	S
						1
2	3	4	5	6	7	8
9	10	11	12	13	14	15
16	17	18	19	20	21	22
23	24	25	26	27	28	29

MARCH

S	M	T	W	Th	F	S
1	2	3	4	5	6	7
8	9	10	11	12	13	14
15	16	17	18	19	20	21
22	23	24	25	26	27	28
29	30	31				

APRIL

S	M	T	W	Th	F	S
			1	2	3	4
5	6	7	8	9	10	11
12	13	14	15	16	17	18
19	20	21	22	23	24	25
26	27	28	29	30		

MAY

S	M	T	W	Th	F	S
					1	2
3	4	5	6	7	8	9
10	11	12	13	14	15	16
17	18	19	20	21	22	23
24	25	26	27	28	29	30
31						

JUNE

S	M	T	W	Th	F	S
	1	2	3	4	5	6
7	8	9	10	11	12	13
14	15	16	17	18	19	20
21	22	23	24	25	26	27
28	29	30				

2020 AT A GLANCE

JULY

S	M	T	W	Th	F	S
			1	2	3	4
5	6	7	8	9	10	11
12	13	14	15	16	17	18
19	20	21	22	23	24	25
26	27	28	29	30	31	

AUGUST

S	M	T	W	Th	F	S
						1
2	3	4	5	6	7	8
9	10	11	12	13	14	15
16	17	18	19	20	21	22
23	24	25	26	27	28	29
30	31					

SEPTEMBER

S	M	T	W	Th	F	S
		1	2	3	4	5
6	7	8	9	10	11	12
13	14	15	16	17	18	19
20	21	22	23	24	25	26
27	28	29	30			

OCTOBER

S	M	T	W	Th	F	S
				1	2	3
4	5	6	7	8	9	10
11	12	13	14	15	16	17
18	19	20	21	22	23	24
25	26	27	28	29	30	31

NOVEMBER

S	M	T	W	Th	F	S
1	2	3	4	5	6	7
8	9	10	11	12	13	14
15	16	17	18	19	20	21
22	23	24	25	26	27	28
29	30					

DECEMBER

S	M	T	W	Th	F	S
		1	2	3	4	5
6	7	8	9	10	11	12
13	14	15	16	17	18	19
20	21	22	23	24	25	26
27	28	29	30	31		

DON'T FORGET

JANUARY

FEBRUARY

MARCH

APRIL

MAY

JUNE

DON'T FORGET

JULY

AUGUST

SEPTEMBER

OCTOBER

NOVEMBER

DECEMBER

CONTACTS

CONTACTS

ACCOUNTS

ACCOUNT _____

USERNAME _____

PW HINT _____

ACCOUNT _____

USERNAME _____

PW HINT _____

ACCOUNT _____

USERNAME _____

PW HINT _____

ACCOUNT _____

USERNAME _____

PW HINT _____

ACCOUNT _____

USERNAME _____

PW HINT _____

ACCOUNT _____

USERNAME _____

PW HINT _____

ACCOUNT _____

USERNAME _____

PW HINT _____

ACCOUNT _____

USERNAME _____

PW HINT _____

ACCOUNT _____

USERNAME _____

PW HINT _____

ACCOUNT _____

USERNAME _____

PW HINT _____

ACCOUNT _____

USERNAME _____

PW HINT _____

ACCOUNT _____

USERNAME _____

PW HINT _____

ACCOUNT _____

USERNAME _____

PW HINT _____

ACCOUNT _____

USERNAME _____

PW HINT _____

artwork by **ILANA GRIFFO**
www.ilanagriffo.com | @ilanagriffo

JANUARY 2020

SUNDAY	MONDAY	TUESDAY	WEDNESDAY
			NEW YEAR'S DAY
5	6	7	
12	13	14	1
19	20	21	2
	MARTIN LUTHER KING, JR. DAY		
26	27	28	2

THURSDAY	FRIDAY	SATURDAY	NOTES
2	3	4	
9	10	11	
16	17	18	
23	24	25	
30	31		

01

JANUARY
GOALS

20

LAST MONTH'S HIGH FIVES:

- _____
- _____
- _____
- _____
- _____

o————————————————————o

THIS MONTH'S GOALS:

WHAT'S THE MOTIVATION?

STEPS TO GET THERE:

]_____
]_____
]_____
]_____
]_____
]_____

THIS MONTH'S BUDGET

INCOME	PLANNED	ACTUAL
Earned		
Other Income		
Total Income		

EXPENSES	PLANNED	ACTUAL
Housing		
Utilities		
Groceries		
Transportation		
TOTAL EXPENDITURES		

SPENDING LOG

DATE	$	DESCRIPTION

TOTAL $ _____

JANUARY 2020

PRIORITIES *(top 5):*

☐ _____
☐ _____
☐ _____
☐ _____
☐ _____

TO DO *(action items):*

☐ _____
☐ _____
☐ _____
☐ _____
☐ _____
☐ _____
☐ _____
☐ _____
☐ _____
☐ _____

HABIT TRACKER:

	M	T	W	Th	F	S	Su
	☐	☐	☐	☐	☐	☐	☐
	☐	☐	☐	☐	☐	☐	☐
	☐	☐	☐	☐	☐	☐	☐

NOTES:

M
30

T
31

W
1

Th
2

F
3

S
4

Su
5

JANUARY 2020

PRIORITIES *(top 5):*

☐

☐

☐

☐

☐

TO DO *(action items):*

☐

☐

☐

☐

☐

☐

☐

☐

☐

☐

HABIT TRACKER:

	M	T	W	Th	F	S	Su
	☐	☐	☐	☐	☐	☐	☐
	☐	☐	☐	☐	☐	☐	☐
	☐	☐	☐	☐	☐	☐	☐

NOTES:

M 6

T 7

W 8

Th 9

F 10

S 11

Su 12

JANUARY 2020

PRIORITIES *(top 5):*

- ☐
- ☐
- ☐
- ☐
- ☐

TO DO *(action items):*

- ☐
- ☐
- ☐
- ☐
- ☐
- ☐
- ☐
- ☐
- ☐
- ☐

HABIT TRACKER:

	M	T	W	Th	F	S	Su
	☐	☐	☐	☐	☐	☐	☐
	☐	☐	☐	☐	☐	☐	☐
	☐	☐	☐	☐	☐	☐	☐

NOTES:

M 13

T 14

W 15

Th 16

F 17

S 18

Su 19

JANUARY 2020

PRIORITIES *(top 5):*

☐ _____
☐ _____
☐ _____
☐ _____
☐ _____

TO DO *(action items):*

☐ _____
☐ _____
☐ _____
☐ _____
☐ _____
☐ _____
☐ _____
☐ _____
☐ _____
☐ _____

HABIT TRACKER:

	M	T	W	Th	F	S	Su
	☐	☐	☐	☐	☐	☐	☐
	☐	☐	☐	☐	☐	☐	☐
	☐	☐	☐	☐	☐	☐	☐

NOTES:

M /20

T /21

W /22

Th /23

F /24

S /25

Su /26

JANUARY 2020

PRIORITIES *(top 5):*

☐ _____

☐ _____

☐ _____

☐ _____

☐ _____

TO DO *(action items):*

☐ _____

☐ _____

☐ _____

☐ _____

☐ _____

☐ _____

☐ _____

☐ _____

☐ _____

☐ _____

HABIT TRACKER:

	M	T	W	Th	F	S	Su
	☐	☐	☐	☐	☐	☐	☐
	☐	☐	☐	☐	☐	☐	☐
	☐	☐	☐	☐	☐	☐	☐

NOTES:

T 27	
T 28	
W 29	
Th 30	
F 31	
S 1	Su 2

NOTES

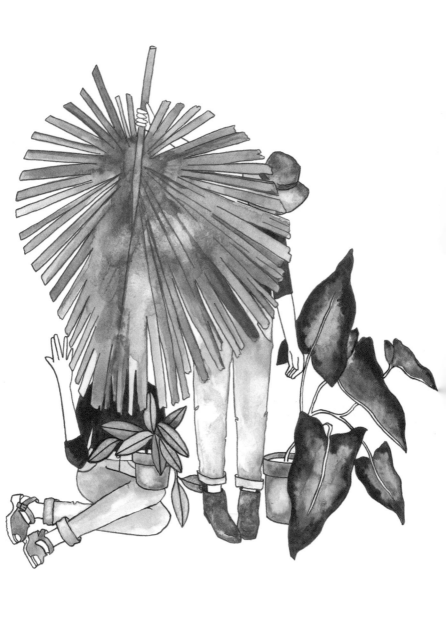

FEBRUARY 2020

SUNDAY	MONDAY	TUESDAY	WEDNESDAY
2	3	4	5
9	10	11	12
16	17	18	19
	PRESIDENT'S DAY		
23	24	25	26

THURSDAY	FRIDAY	SATURDAY	NOTES
		1	
6	7	8	
13	14	15	
20	21	22	
27	28	29	

MARCH

S	M	T	W	Th	F	S
						1
1	2	3	4	5	6	7
8	9	10	11	12	13	14
15	16	17	18	19	20	21
22	23	24	25	26	27	28
29	30	31				

APRIL

S	M	T	W	Th	F	S
			1	2	3	4
5	6	7	8	9	10	11
12	13	14	15	16	17	18
19	20	21	22	23	24	25
26	27	28	29	30		

02

FEBRUARY
GOALS

20

LAST MONTH'S HIGH FIVES:

- _____
- _____
- _____
- _____
- _____

THIS MONTH'S GOALS:

WHAT'S THE MOTIVATION?

STEPS TO GET THERE:

THIS MONTH'S BUDGET

INCOME	PLANNED	ACTUAL
Earned		
Other Income		
Total Income		

EXPENSES	PLANNED	ACTUAL
Housing		
Utilities		
Groceries		
Transportation		
TOTAL EXPENDITURES		

SPENDING LOG

DATE	$	DESCRIPTION

TOTAL $ _____

FEBRUARY 2020

PRIORITIES *(top 5):*

☐ _____

☐ _____

☐ _____

☐ _____

☐ _____

TO DO *(action items):*

☐ _____

☐ _____

☐ _____

☐ _____

☐ _____

☐ _____

☐ _____

☐ _____

☐ _____

☐ _____

HABIT TRACKER:

	M	T	W	Th	F	S	Su
	☐	☐	☐	☐	☐	☐	☐
	☐	☐	☐	☐	☐	☐	☐
	☐	☐	☐	☐	☐	☐	☐

NOTES:

M
3

T
4

W
5

Th
6

F
7

S
8

Su
9

FEBRUARY 2020

PRIORITIES *(top 5):*

☐ _____

☐ _____

☐ _____

☐ _____

☐ _____

TO DO *(action items):*

☐ _____

☐ _____

☐ _____

☐ _____

☐ _____

☐ _____

☐ _____

☐ _____

☐ _____

☐ _____

HABIT TRACKER:	M	T	W	Th	F	S	Su
	☐	☐	☐	☐	☐	☐	☐
	☐	☐	☐	☐	☐	☐	☐
	☐	☐	☐	☐	☐	☐	☐

NOTES:

M
10

T
11

W
12

Th
13

F
14

S
15

Su
16

FEBRUARY 2020

PRIORITIES *(top 5):*

☐ _____

☐ _____

☐ _____

☐ _____

☐ _____

TO DO *(action items):*

☐ _____

☐ _____

☐ _____

☐ _____

☐ _____

☐ _____

☐ _____

☐ _____

☐ _____

☐ _____

HABIT TRACKER:

	M	T	W	Th	F	S	Su
	☐	☐	☐	☐	☐	☐	☐
	☐	☐	☐	☐	☐	☐	☐
	☐	☐	☐	☐	☐	☐	☐

NOTES:

17

18

19

20

F
21

S
22

Su
23

FEBRUARY 2020

PRIORITIES *(top 5):*

☐ _____
☐ _____
☐ _____
☐ _____
☐ _____

TO DO *(action items):*

☐ _____
☐ _____
☐ _____
☐ _____
☐ _____
☐ _____
☐ _____
☐ _____
☐ _____
☐ _____

HABIT TRACKER:

	M	T	W	Th	F	S	Su
	☐	☐	☐	☐	☐	☐	☐
	☐	☐	☐	☐	☐	☐	☐
	☐	☐	☐	☐	☐	☐	☐

NOTES:

T
/ 24

T
/ 25

W
/ 26

Th
/ 27

F
/ 28

S
/ 29

Su
/ 1

NOTES

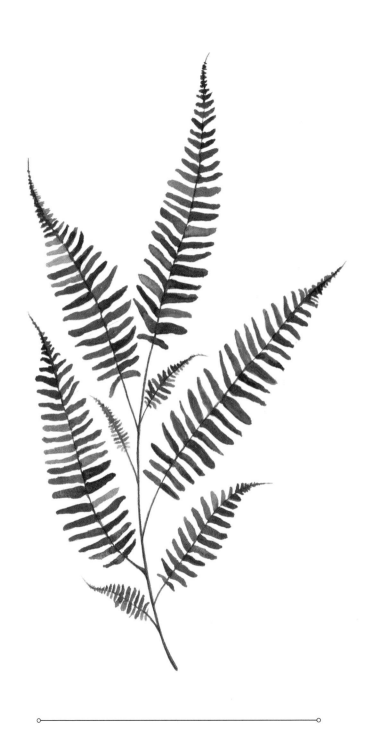

MARCH 2020

SUNDAY	MONDAY	TUESDAY	WEDNESDAY
1	2	3	4
8	9	10	11
15	16	17	18
22	23	24	25
29	30	31	

THURSDAY	FRIDAY	SATURDAY	NOTES
5	6	7	
12	13	14	
19	20	21	
26	27	28	

APRIL

S	M	T	W	Th	F	S
			1	2	3	4
5	6	7	8	9	10	11
12	13	14	15	16	17	18
19	20	21	22	23	24	25
26	27	28	29	30		

MAY

S	M	T	W	Th	F	S
					1	2
3	4	5	6	7	8	9
10	11	12	13	14	15	16
17	18	19	20	21	22	23
24	25	26	27	28	29	30
31						

03

MARCH
GOALS

20

LAST MONTH'S HIGH FIVES:

- _____
- _____
- _____
- _____
- _____

o———————————————————o

THIS MONTH'S GOALS:

] _____
] _____
] _____
] _____
] _____
] _____

WHAT'S THE MOTIVATION?

STEPS TO GET THERE:

] _____
] _____
] _____
] _____
] _____
] _____

THIS MONTH'S BUDGET

INCOME	PLANNED	ACTUAL
Earned		
Other Income		
Total Income		
EXPENSES	**PLANNED**	**ACTUAL**
Housing		
Utilities		
Groceries		
Transportation		
TOTAL EXPENDITURES		

SPENDING LOG

DATE	$	DESCRIPTION

OTAL $ _____

MARCH 2020

PRIORITIES *(top 5):*

☐
☐
☐
☐
☐

TO DO *(action items):*

☐
☐
☐
☐
☐
☐
☐
☐
☐
☐

HABIT TRACKER:

	M	T	W	Th	F	S	Su
	☐	☐	☐	☐	☐	☐	☐
	☐	☐	☐	☐	☐	☐	☐
	☐	☐	☐	☐	☐	☐	☐

NOTES:

2	
3	
4	
5	
6	
S 7	**Su** 8

MARCH 2020

PRIORITIES *(top 5)*:

☐ _____

☐ _____

☐ _____

☐ _____

☐ _____

TO DO *(action items)*:

☐ _____

☐ _____

☐ _____

☐ _____

☐ _____

☐ _____

☐ _____

☐ _____

☐ _____

☐ _____

HABIT TRACKER:

	M	T	W	Th	F	S	Su
	☐	☐	☐	☐	☐	☐	☐
	☐	☐	☐	☐	☐	☐	☐
	☐	☐	☐	☐	☐	☐	☐

NOTES:

9

10

11

12

13

14

Su
15

MARCH 2020

PRIORITIES *(top 5):*

- ☐
- ☐
- ☐
- ☐
- ☐

TO DO *(action items):*

- ☐
- ☐
- ☐
- ☐
- ☐
- ☐
- ☐
- ☐
- ☐
- ☐

HABIT TRACKER:

	M	T	W	Th	F	S	Su
	☐	☐	☐	☐	☐	☐	☐
	☐	☐	☐	☐	☐	☐	☐
	☐	☐	☐	☐	☐	☐	☐

NOTES:

16

17

18

19

20

21

Su
22

MARCH 2020

PRIORITIES *(top 5):*

☐
☐
☐
☐
☐

TO DO *(action items):*

☐
☐
☐
☐
☐
☐
☐
☐
☐
☐

HABIT TRACKER:

	M	T	W	Th	F	S	Su
	☐	☐	☐	☐	☐	☐	☐
	☐	☐	☐	☐	☐	☐	☐
	☐	☐	☐	☐	☐	☐	☐

NOTES:

23

24

25

26

27

28

Su
29

MARCH 2020

PRIORITIES *(top 5):*

- ☐ _____
- ☐ _____
- ☐ _____
- ☐ _____
- ☐ _____

TO DO *(action items):*

- ☐ _____
- ☐ _____
- ☐ _____
- ☐ _____
- ☐ _____
- ☐ _____
- ☐ _____
- ☐ _____
- ☐ _____
- ☐ _____

HABIT TRACKER:

	M	T	W	Th	F	S	Su
	☐	☐	☐	☐	☐	☐	☐
	☐	☐	☐	☐	☐	☐	☐
	☐	☐	☐	☐	☐	☐	☐

NOTES:

30

31

1

2

3

4

5

NOTES

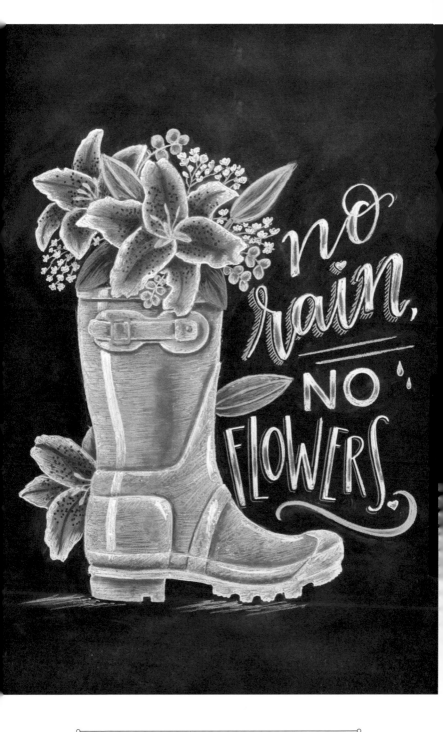

no rain, NO FLOWERS

artwork by **SHANNON ROBERTS**
Etsy - TheWhiteLime | @shannonroberts19

APRIL 2020

SUNDAY	MONDAY	TUESDAY	WEDNESDAY
			1
5	6	7	8
12	13	14	15
19	20	21	22
26	27	28	29

THURSDAY	FRIDAY	SATURDAY	NOTES
2	3	4	_____

9	10	11	_____

16	17	18	_____

23	24	25	_____
30			

MAY

S	M	T	W	Th	F	S
					1	2
3	4	5	6	7	8	9
10	11	12	13	14	15	16
17	18	19	20	21	22	23
24	25	26	27	28	29	30
31						

JUNE

S	M	T	W	Th	F	S
	1	2	3	4	5	6
7	8	9	10	11	12	13
14	15	16	17	18	19	20
21	22	23	24	25	26	27
28	29	30				

04

APRIL
GOALS

20

LAST MONTH'S HIGH FIVES:

- _____
- _____
- _____
- _____
- _____

o————————————————————o

THIS MONTH'S GOALS:

] _____
] _____
] _____
] _____
] _____
] _____

WHAT'S THE MOTIVATION?

STEPS TO GET THERE:

] _____
] _____
] _____
] _____
] _____
] _____

THIS MONTH'S BUDGET

INCOME	PLANNED	ACTUAL
Earned		
Other Income		
Total Income		

EXPENSES	PLANNED	ACTUAL
Housing		
Utilities		
Groceries		
Transportation		
TOTAL EXPENDITURES		

SPENDING LOG

DATE	$	DESCRIPTION

TOTAL $ _____

APRIL 2020

PRIORITIES *(top 5):*

- []
- []
- []
- []
- []

TO DO *(action items):*

- []
- []
- []
- []
- []
- []
- []
- []
- []
- []

HABIT TRACKER:	M	T	W	Th	F	S	Su
	☐	☐	☐	☐	☐	☐	☐
	☐	☐	☐	☐	☐	☐	☐
	☐	☐	☐	☐	☐	☐	☐

NOTES:

6

7

8

9

F
10

S
11

Su
12

APRIL 2020

PRIORITIES *(top 5)*:

- []
- []
- []
- []
- []

TO DO *(action items)*:

- []
- []
- []
- []
- []
- []
- []
- []
- []
- []

HABIT TRACKER:

	M	T	W	Th	F	S	Su
	☐	☐	☐	☐	☐	☐	☐
	☐	☐	☐	☐	☐	☐	☐
	☐	☐	☐	☐	☐	☐	☐

NOTES:

M
13

T
14

W
15

Th
16

F
17

S
18

Su
19

APRIL 2020

PRIORITIES *(top 5):*

☐ _____
☐ _____
☐ _____
☐ _____
☐ _____

TO DO *(action items):*

☐ _____
☐ _____
☐ _____
☐ _____
☐ _____
☐ _____
☐ _____
☐ _____
☐ _____
☐ _____

HABIT TRACKER:

	M	T	W	Th	F	S	Su
	☐	☐	☐	☐	☐	☐	☐
	☐	☐	☐	☐	☐	☐	☐
	☐	☐	☐	☐	☐	☐	☐

NOTES:

20

21

22

h
23

F
24

S
25

Su
26

APRIL 2020

PRIORITIES *(top 5):*

- []
- []
- []
- []
- []

TO DO *(action items):*

- []
- []
- []
- []
- []
- []
- []
- []
- []
- []

HABIT TRACKER:

	M	T	W	Th	F	S	Su
	☐	☐	☐	☐	☐	☐	☐
	☐	☐	☐	☐	☐	☐	☐
	☐	☐	☐	☐	☐	☐	☐

NOTES:

27

28

V 29

h 30

F 1

S 2

Su 3

NOTES

artwork by **KORIE HEROLD**
www.theweekendtype.com | @theweekendtype

MAY 2020

SUNDAY	MONDAY	TUESDAY	WEDNESDAY
3	4	5	6
10	11	12	13
17	18	19	20
24	25	26	27
31	MEMORIAL DAY		

THURSDAY	FRIDAY	SATURDAY	NOTES
	1	2	
7	8	9	
14	15	16	
21	22	23	
28	29	30	

JUNE

S	M	T	W	Th	F	S
	1	2	3	4	5	6
7	8	9	10	11	12	13
14	15	16	17	18	19	20
21	22	23	24	25	26	27
28	29	30				

JULY

S	M	T	W	Th	F	S
			1	2	3	4
5	6	7	8	9	10	11
12	13	14	15	16	17	18
19	20	21	22	23	24	25
26	27	28	29	30	31	

05

**MAY
GOALS**

20

LAST MONTH'S HIGH FIVES:

- _____
- _____
- _____
- _____
- _____

o———————————————o

THIS MONTH'S GOALS:

WHAT'S THE MOTIVATION?

STEPS TO GET THERE:

- [] _____
- [] _____
- [] _____
- [] _____
- [] _____
- [] _____

THIS MONTH'S BUDGET

INCOME	PLANNED	ACTUAL
Earned		
Other Income		
Total Income		

EXPENSES	PLANNED	ACTUAL
Housing		
Utilities		
Groceries		
Transportation		
TOTAL EXPENDITURES		

SPENDING LOG

DATE	$	DESCRIPTION

TOTAL $ _____

MAY 2020

PRIORITIES *(top 5):*

- ☐
- ☐
- ☐
- ☐
- ☐

TO DO *(action items):*

- ☐
- ☐
- ☐
- ☐
- ☐
- ☐
- ☐
- ☐
- ☐
- ☐

HABIT TRACKER:

	M	T	W	Th	F	S	Su
	☐	☐	☐	☐	☐	☐	☐
	☐	☐	☐	☐	☐	☐	☐
	☐	☐	☐	☐	☐	☐	☐

NOTES:

4

5

6

7

8

S 9

Su 10

MAY 2020

PRIORITIES *(top 5):*

- []
- []
- []
- []
- []

TO DO *(action items):*

- []
- []
- []
- []
- []
- []
- []
- []
- []
- []

HABIT TRACKER:

	M	T	W	Th	F	S	Su
	☐	☐	☐	☐	☐	☐	☐
	☐	☐	☐	☐	☐	☐	☐
	☐	☐	☐	☐	☐	☐	☐

NOTES:

11

12

13

14

15

16

Su
17

MAY 2020

PRIORITIES *(top 5):*

- []
- []
- []
- []
- []

TO DO *(action items):*

- []
- []
- []
- []
- []
- []
- []
- []
- []
- []

HABIT TRACKER:

	M	T	W	Th	F	S	Su
	[]	[]	[]	[]	[]	[]	[]
	[]	[]	[]	[]	[]	[]	[]
	[]	[]	[]	[]	[]	[]	[]

NOTES:

18

19

20

21

22

23

Su
24

MAY 2020

PRIORITIES *(top 5):*

☐ _____

☐ _____

☐ _____

☐ _____

☐ _____

TO DO *(action items):*

☐ _____

☐ _____

☐ _____

☐ _____

☐ _____

☐ _____

☐ _____

☐ _____

☐ _____

☐ _____

HABIT TRACKER:	M	T	W	Th	F	S	Su
	☐	☐	☐	☐	☐	☐	☐
	☐	☐	☐	☐	☐	☐	☐
	☐	☐	☐	☐	☐	☐	☐

NOTES:

25

26

27

28

29

30

Su
31

NOTES

JUNE 2020

SUNDAY	MONDAY	TUESDAY	WEDNESDAY
	1	2	3
7	8	9	10
14	15	16	17
21	22	23	24
28	29	30	

THURSDAY	FRIDAY	SATURDAY	NOTES
4	5	6	
11	12	13	
18	19	20	
25	26	27	

JULY

S	M	T	W	Th	F	S
			1	2	3	4
5	6	7	8	9	10	11
12	13	14	15	16	17	18
19	20	21	22	23	24	25
26	27	28	29	30	31	

AUGUST

S	M	T	W	Th	F	S
						1
2	3	4	5	6	7	8
9	10	11	12	13	14	15
16	17	18	19	20	21	22
23	24	25	26	27	28	29
30	31					

06

JUNE
GOALS

20

LAST MONTH'S HIGH FIVES:

- _____
- _____
- _____
- _____
- _____

o———————————————o

THIS MONTH'S GOALS:

WHAT'S THE MOTIVATION?

STEPS TO GET THERE:

THIS MONTH'S BUDGET

INCOME	PLANNED	ACTUAL
Earned		
Other Income		
Total Income		

EXPENSES	PLANNED	ACTUAL
Housing		
Utilities		
Groceries		
Transportation		
TOTAL EXPENDITURES		

SPENDING LOG

DATE	$	DESCRIPTION

TOTAL $ _____

JUNE 2020

PRIORITIES *(top 5):*

- []
- []
- []
- []
- []

TO DO *(action items):*

- []
- []
- []
- []
- []
- []
- []
- []
- []
- []

HABIT TRACKER:

	M	T	W	Th	F	S	Su
	☐	☐	☐	☐	☐	☐	☐
	☐	☐	☐	☐	☐	☐	☐
	☐	☐	☐	☐	☐	☐	☐

NOTES:

1	
2	
3	
4	
5	
6	Su 7

JUNE 2020

PRIORITIES *(top 5)*:

- ☐
- ☐
- ☐
- ☐
- ☐

TO DO *(action items)*:

- ☐
- ☐
- ☐
- ☐
- ☐
- ☐
- ☐
- ☐
- ☐
- ☐

HABIT TRACKER:

	M	T	W	Th	F	S	Su
	☐	☐	☐	☐	☐	☐	☐
	☐	☐	☐	☐	☐	☐	☐
	☐	☐	☐	☐	☐	☐	☐

NOTES:

8

9

10

11

12

13

Su
14

JUNE 2020

PRIORITIES *(top 5):*

☐ _____

☐ _____

☐ _____

☐ _____

☐ _____

TO DO *(action items):*

☐ _____

☐ _____

☐ _____

☐ _____

☐ _____

☐ _____

☐ _____

☐ _____

☐ _____

☐ _____

HABIT TRACKER:	M	T	W	Th	F	S	Su
	☐	☐	☐	☐	☐	☐	☐
	☐	☐	☐	☐	☐	☐	☐
	☐	☐	☐	☐	☐	☐	☐

NOTES:

15

16

17

18

19

20

Su
21

JUNE 2020

PRIORITIES *(top 5):*

☐ _____

☐ _____

☐ _____

☐ _____

☐ _____

TO DO *(action items):*

☐ _____

☐ _____

☐ _____

☐ _____

☐ _____

☐ _____

☐ _____

☐ _____

☐ _____

☐ _____

HABIT TRACKER:	M	T	W	Th	F	S	Su
	☐	☐	☐	☐	☐	☐	☐
	☐	☐	☐	☐	☐	☐	☐
	☐	☐	☐	☐	☐	☐	☐

NOTES:

22

23

24

25

26

27

Su
28

JUNE 2020

PRIORITIES *(top 5):*

☐ _____

☐ _____

☐ _____

☐ _____

☐ _____

TO DO *(action items):*

☐ _____

☐ _____

☐ _____

☐ _____

☐ _____

☐ _____

☐ _____

☐ _____

☐ _____

☐ _____

HABIT TRACKER:	M	T	W	Th	F	S	Su
	☐	☐	☐	☐	☐	☐	☐
	☐	☐	☐	☐	☐	☐	☐
	☐	☐	☐	☐	☐	☐	☐

NOTES:

29

30

1

2

3

4

Su 5

NOTES

artwork by **SHANNON ROBERTS**
Etsy - TheWhiteLime | @shannonroberts19

JULY 2020

SUNDAY	MONDAY	TUESDAY	WEDNESDAY
5	6	7	8
12	13	14	1
19	20	21	2
26	27	28	2

THURSDAY	FRIDAY	SATURDAY	NOTES
2	3	4	
		INDEPENDENCE DAY	
9	10	11	
16	17	18	
23	24	25	
30	31		

AUGUST

S	M	T	W	Th	F	S
						1
2	3	4	5	6	7	8
9	10	11	12	13	14	15
16	17	18	19	20	21	22
23	24	25	26	27	28	29
30	31					

SEPTEMBER

S	M	T	W	Th	F	S
		1	2	3	4	5
6	7	8	9	10	11	12
13	14	15	16	17	18	19
20	21	22	23	24	25	26
27	28	29	30			

07

JULY
GOALS

20

LAST MONTH'S HIGH FIVES:

- _____
- _____
- _____
- _____
- _____

THIS MONTH'S GOALS:

WHAT'S THE MOTIVATION?

STEPS TO GET THERE:

THIS MONTH'S BUDGET

INCOME	PLANNED	ACTUAL
Earned		
Other Income		
Total Income		

EXPENSES	PLANNED	ACTUAL
Housing		
Utilities		
Groceries		
Transportation		
TOTAL EXPENDITURES		

SPENDING LOG

DATE	$	DESCRIPTION

TOTAL $ _____

JULY 2020

PRIORITIES *(top 5)*:

- ☐
- ☐
- ☐
- ☐
- ☐

TO DO *(action items)*:

- ☐
- ☐
- ☐
- ☐
- ☐
- ☐
- ☐
- ☐
- ☐
- ☐

HABIT TRACKER:

	M	T	W	Th	F	S	Su
	☐	☐	☐	☐	☐	☐	☐
	☐	☐	☐	☐	☐	☐	☐
	☐	☐	☐	☐	☐	☐	☐

NOTES:

6

7

8

9

10

11

Su 12

JULY 2020

PRIORITIES *(top 5):*

- []
- []
- []
- []
- []

TO DO *(action items):*

- []
- []
- []
- []
- []
- []
- []
- []
- []
- []

HABIT TRACKER:

	M	T	W	Th	F	S	Su
	☐	☐	☐	☐	☐	☐	☐
	☐	☐	☐	☐	☐	☐	☐
	☐	☐	☐	☐	☐	☐	☐

NOTES:

13

14

15

16

17

18

Su
19

JULY 2020

PRIORITIES *(top 5):*

- ☐
- ☐
- ☐
- ☐
- ☐

TO DO *(action items):*

- ☐
- ☐
- ☐
- ☐
- ☐
- ☐
- ☐
- ☐
- ☐
- ☐

HABIT TRACKER:

	M	T	W	Th	F	S	Su
	☐	☐	☐	☐	☐	☐	☐
	☐	☐	☐	☐	☐	☐	☐
	☐	☐	☐	☐	☐	☐	☐

NOTES:

20

21

22

23

24

25

Su
26

JULY 2020

PRIORITIES *(top 5):*

- []
- []
- []
- []
- []

TO DO *(action items):*

- []
- []
- []
- []
- []
- []
- []
- []
- []
- []

HABIT TRACKER:

	M	T	W	Th	F	S	Su
	☐	☐	☐	☐	☐	☐	☐
	☐	☐	☐	☐	☐	☐	☐
	☐	☐	☐	☐	☐	☐	☐

NOTES:

M 27

T 28

W 29

Th 30

F 31

S 1

Su 2

NOTES

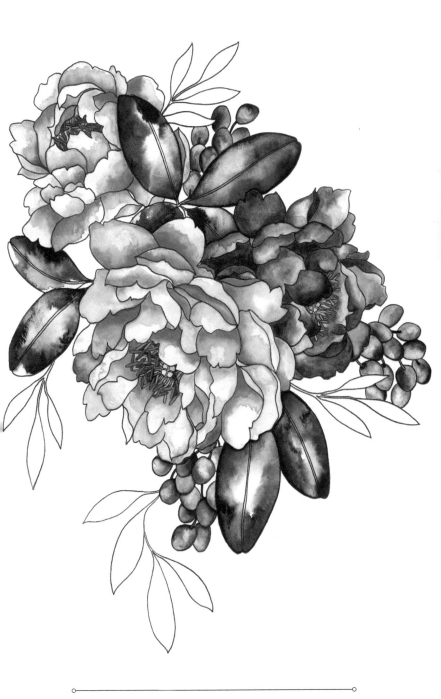

AUGUST 2020

SUNDAY	MONDAY	TUESDAY	WEDNESDAY
2	3	4	5
9	10	11	12
16	17	18	19
23	24	25	26
30	31		

THURSDAY	FRIDAY	SATURDAY	NOTES
		1	
6	7	8	
13	14	15	
20	21	22	
27	28	29	

SEPTEMBER

S	M	T	W	Th	F	S
		1	2	3	4	5
6	7	8	9	10	11	12
13	14	15	16	17	18	19
20	21	22	23	24	25	26
27	28	29	30			

OCTOBER

S	M	T	W	Th	F	S
				1	2	3
4	5	6	7	8	9	10
11	12	13	14	15	16	17
18	19	20	21	22	23	24
25	26	27	28	29	30	31

08

**AUGUST
GOALS**

20

LAST MONTH'S HIGH FIVES:

- _____
- _____
- _____
- _____
- _____

o——————————————————————o

THIS MONTH'S GOALS:

☐ _____
☐ _____
☐ _____
☐ _____
☐ _____
☐ _____

WHAT'S THE MOTIVATION?

STEPS TO GET THERE:

☐ _____
☐ _____
☐ _____
☐ _____
☐ _____
☐ _____

THIS MONTH'S BUDGET

INCOME	PLANNED	ACTUAL
Earned		
Other Income		
Total Income		

EXPENSES	PLANNED	ACTUAL
Housing		
Utilities		
Groceries		
Transportation		
TOTAL EXPENDITURES		

SPENDING LOG

DATE	$	DESCRIPTION

TAL $ _____

AUGUST 2020

PRIORITIES *(top 5):*

- []
- []
- []
- []
- []

TO DO *(action items):*

- []
- []
- []
- []
- []
- []
- []
- []
- []
- []

HABIT TRACKER:

	M	T	W	Th	F	S	Su
	[]	[]	[]	[]	[]	[]	[]
	[]	[]	[]	[]	[]	[]	[]
	[]	[]	[]	[]	[]	[]	[]

NOTES:

M 3

T 4

W 5

h 6

F 7

S 8

Su 9

AUGUST 2020

PRIORITIES *(top 5):*

☐ _____

☐ _____

☐ _____

☐ _____

☐ _____

TO DO *(action items):*

☐ _____

☐ _____

☐ _____

☐ _____

☐ _____

☐ _____

☐ _____

☐ _____

☐ _____

☐ _____

HABIT TRACKER:

	M	T	W	Th	F	S	Su
	☐	☐	☐	☐	☐	☐	☐
	☐	☐	☐	☐	☐	☐	☐
	☐	☐	☐	☐	☐	☐	☐

NOTES:

M
10

T
11

W
12

Th
13

14

15

Su
16

AUGUST 2020

PRIORITIES *(top 5):*

☐ _____

☐ _____

☐ _____

☐ _____

☐ _____

TO DO *(action items):*

☐ _____

☐ _____

☐ _____

☐ _____

☐ _____

☐ _____

☐ _____

☐ _____

☐ _____

☐ _____

HABIT TRACKER:

	M	T	W	Th	F	S	Su
	☐	☐	☐	☐	☐	☐	☐
	☐	☐	☐	☐	☐	☐	☐
	☐	☐	☐	☐	☐	☐	☐

NOTES:

17

18

19

20

21

22

Su
23

AUGUST 2020

PRIORITIES *(top 5):*

- ☐
- ☐
- ☐
- ☐
- ☐

TO DO *(action items):*

- ☐
- ☐
- ☐
- ☐
- ☐
- ☐
- ☐
- ☐
- ☐
- ☐

HABIT TRACKER:

	M	T	W	Th	F	S	Su
	☐	☐	☐	☐	☐	☐	☐
	☐	☐	☐	☐	☐	☐	☐
	☐	☐	☐	☐	☐	☐	☐

NOTES:

24

25

26

27

28

29

Su
30

NOTES

do the things that make you lose track of time

artwork by **ILANA GRIFFO**
www.ilanagriffo.com | @ilanagriffo

SEPTEMBER 2020

SUNDAY	MONDAY	TUESDAY	WEDNESDAY
		1	2
6	7	8	9
	LABOR DAY		
13	14	15	16
20	21	22	23
27	28	29	30

THURSDAY	FRIDAY	SATURDAY	NOTES
3	4	5	
10	11	12	
17	18	19	
24	25	26	

OCTOBER

S	M	T	W	Th	F	S
				1	2	3
4	5	6	7	8	9	10
11	12	13	14	15	16	17
18	19	20	21	22	23	24
25	26	27	28	29	30	31

NOVEMBER

S	M	T	W	Th	F	S
1	2	3	4	5	6	7
8	9	10	11	12	13	14
15	16	17	18	19	20	21
22	23	24	25	26	27	28
29	30					

09

SEPTEMBER
GOALS

20

LAST MONTH'S HIGH FIVES:

- _____
- _____
- _____
- _____
- _____

THIS MONTH'S GOALS:

WHAT'S THE MOTIVATION?

STEPS TO GET THERE:

THIS MONTH'S BUDGET

INCOME	PLANNED	ACTUAL
Earned		
Other Income		
Total Income		

EXPENSES	PLANNED	ACTUAL
Housing		
Utilities		
Groceries		
Transportation		
TOTAL EXPENDITURES		

SPENDING LOG

DATE	$	DESCRIPTION

TOTAL $ _____

SEPTEMBER 2020

PRIORITIES *(top 5):*

- []
- []
- []
- []
- []

TO DO *(action items):*

- []
- []
- []
- []
- []
- []
- []
- []
- []
- []

HABIT TRACKER:

	M	T	W	Th	F	S	Su
	☐	☐	☐	☐	☐	☐	☐
	☐	☐	☐	☐	☐	☐	☐
	☐	☐	☐	☐	☐	☐	☐

NOTES:

31

1

2

3

4

5

Su
6

SEPTEMBER 2020

PRIORITIES *(top 5)*:

☐ _____

☐ _____

☐ _____

☐ _____

☐ _____

TO DO *(action items)*:

☐ _____

☐ _____

☐ _____

☐ _____

☐ _____

☐ _____

☐ _____

☐ _____

☐ _____

☐ _____

HABIT TRACKER:

	M	T	W	Th	F	S	Su
	☐	☐	☐	☐	☐	☐	☐
	☐	☐	☐	☐	☐	☐	☐
	☐	☐	☐	☐	☐	☐	☐

NOTES:

7

8

9

10

11

12

Su 13

SEPTEMBER 2020

PRIORITIES *(top 5):*

- ☐
- ☐
- ☐
- ☐
- ☐

TO DO *(action items):*

- ☐
- ☐
- ☐
- ☐
- ☐
- ☐
- ☐
- ☐
- ☐
- ☐

HABIT TRACKER:

	M	T	W	Th	F	S	Su
	☐	☐	☐	☐	☐	☐	☐
	☐	☐	☐	☐	☐	☐	☐
	☐	☐	☐	☐	☐	☐	☐

NOTES:

14

15

16

17

18

19

Su
20

SEPTEMBER 2020

PRIORITIES *(top 5):*

- []
- []
- []
- []
- []

TO DO *(action items):*

- []
- []
- []
- []
- []
- []
- []
- []
- []
- []

HABIT TRACKER:

	M	T	W	Th	F	S	Su
	☐	☐	☐	☐	☐	☐	☐
	☐	☐	☐	☐	☐	☐	☐
	☐	☐	☐	☐	☐	☐	☐

NOTES:

21

22

23

24

25

26

Su
27

SEPTEMBER 2020

PRIORITIES *(top 5)*:

- ☐
- ☐
- ☐
- ☐
- ☐

TO DO *(action items)*:

- ☐
- ☐
- ☐
- ☐
- ☐
- ☐
- ☐
- ☐
- ☐
- ☐

HABIT TRACKER:

	M	T	W	Th	F	S	Su
	☐	☐	☐	☐	☐	☐	☐
	☐	☐	☐	☐	☐	☐	☐
	☐	☐	☐	☐	☐	☐	☐

NOTES:

28

29

30

1

2

3

Su
4

NOTES

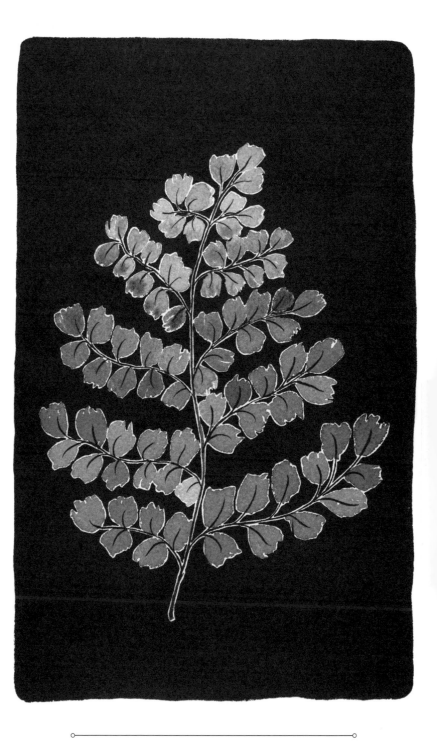

OCTOBER 2020

SUNDAY	MONDAY	TUESDAY	WEDNESDAY
4	5	6	7
11	12	13	14
	COLUMBUS DAY		
18	19	20	2
25	26	27	2

THURSDAY	FRIDAY	SATURDAY	NOTES
1	2	3	_____
8	9	10	_____
15	16	17	_____
22	23	24	_____
29	30	31	

NOVEMBER

S	M	T	W	Th	F	S
1	2	3	4	5	6	7
8	9	10	11	12	13	14
15	16	17	18	19	20	21
22	23	24	25	26	27	28
29	30					

DECEMBER

S	M	T	W	Th	F	S
		1	2	3	4	5
6	7	8	9	10	11	12
13	14	15	16	17	18	19
20	21	22	23	24	25	26
27	28	29	30	31		

10

OCTOBER
GOALS

20

LAST MONTH'S HIGH FIVES:

- _____
- _____
- _____
- _____
- _____

THIS MONTH'S GOALS:

WHAT'S THE MOTIVATION?

STEPS TO GET THERE:

THIS MONTH'S BUDGET

INCOME	PLANNED	ACTUAL
Earned		
Other Income		
Total Income		

EXPENSES	PLANNED	ACTUAL
Housing		
Utilities		
Groceries		
Transportation		
TOTAL EXPENDITURES		

SPENDING LOG

DATE	$	DESCRIPTION

TOTAL $ _____

OCTOBER 2020

PRIORITIES *(top 5):*

☐ _____

☐ _____

☐ _____

☐ _____

☐ _____

TO DO *(action items):*

☐ _____

☐ _____

☐ _____

☐ _____

☐ _____

☐ _____

☐ _____

☐ _____

☐ _____

☐ _____

HABIT TRACKER:

	M	T	W	Th	F	S	Su
	☐	☐	☐	☐	☐	☐	☐
	☐	☐	☐	☐	☐	☐	☐
	☐	☐	☐	☐	☐	☐	☐

NOTES:

5

6

7

8

9

0

Su 11

OCTOBER 2020

PRIORITIES *(top 5):*

☐ _____

☐ _____

☐ _____

☐ _____

☐ _____

TO DO *(action items):*

☐ _____

☐ _____

☐ _____

☐ _____

☐ _____

☐ _____

☐ _____

☐ _____

☐ _____

☐ _____

HABIT TRACKER:	M	T	W	Th	F	S	S
	☐	☐	☐	☐	☐	☐	☐
	☐	☐	☐	☐	☐	☐	☐
	☐	☐	☐	☐	☐	☐	☐

NOTES:

12

13

14

15

16

17

Su
18

OCTOBER 2020

PRIORITIES *(top 5):*

- ☐
- ☐
- ☐
- ☐
- ☐

TO DO *(action items):*

- ☐
- ☐
- ☐
- ☐
- ☐
- ☐
- ☐
- ☐
- ☐
- ☐

HABIT TRACKER:

	M	T	W	Th	F	S	S
	☐	☐	☐	☐	☐	☐	☐
	☐	☐	☐	☐	☐	☐	☐
	☐	☐	☐	☐	☐	☐	☐

NOTES:

19

20

21

22

23

24

Su 25

OCTOBER 2020

PRIORITIES *(top 5):*

- ☐
- ☐
- ☐
- ☐
- ☐

TO DO *(action items):*

- ☐
- ☐
- ☐
- ☐
- ☐
- ☐
- ☐
- ☐
- ☐
- ☐

HABIT TRACKER:

	M	T	W	Th	F	S	Su
	☐	☐	☐	☐	☐	☐	☐
	☐	☐	☐	☐	☐	☐	☐
	☐	☐	☐	☐	☐	☐	☐

NOTES:

26

27

28

29

30

31

Su
1

NOTES

artwork by **TABITHA PAGE**
www.foxhollowstudios.com / @foxhollowstudios

NOVEMBER 2020

SUNDAY	MONDAY	TUESDAY	WEDNESDAY
1	2	3	4
8	9	10	11 VETERANS DAY
15	16	17	18
22	23	24	25
29	30		

THURSDAY	FRIDAY	SATURDAY	NOTES
5	6	7	_____

12	13	14	_____

19	20	21	_____

26	27	28	_____
		THANKSGIVING DAY	

DECEMBER

S	M	T	W	Th	F	S
		1	2	3	4	5
6	7	8	9	10	11	12
13	14	15	16	17	18	19
20	21	22	23	24	25	26
27	28	29	30	31		

JANUARY 2021

S	M	T	W	Th	F	S
					1	2
3	4	5	6	7	8	9
10	11	12	13	14	15	16
17	18	19	20	21	22	23
24	25	26	27	28	29	30
31						

11

———

NOVEMBER
GOALS

———

20

LAST MONTH'S HIGH FIVES:

- _____
- _____
- _____
- _____
- _____
- _____

THIS MONTH'S GOALS:

WHAT'S THE MOTIVATION?

STEPS TO GET THERE:

THIS MONTH'S BUDGET

INCOME	PLANNED	ACTUAL
Earned		
Other Income		
Total Income		

EXPENSES	PLANNED	ACTUAL
Housing		
Utilities		
Groceries		
Transportation		
TOTAL EXPENDITURES		

SPENDING LOG

DATE	$	DESCRIPTION

TOTAL $ _____

NOVEMBER 2020

PRIORITIES *(top 5):*

- ☐
- ☐
- ☐
- ☐
- ☐

TO DO *(action items):*

- ☐
- ☐
- ☐
- ☐
- ☐
- ☐
- ☐
- ☐
- ☐
- ☐

HABIT TRACKER:

	M	T	W	Th	F	S	Su
	☐	☐	☐	☐	☐	☐	☐
	☐	☐	☐	☐	☐	☐	☐
	☐	☐	☐	☐	☐	☐	☐

NOTES:

2

3

4

5

6

7

Su
8

NOVEMBER 2020

PRIORITIES *(top 5):*

- ☐ _____
- ☐ _____
- ☐ _____
- ☐ _____
- ☐ _____

TO DO *(action items):*

- ☐ _____
- ☐ _____
- ☐ _____
- ☐ _____
- ☐ _____
- ☐ _____
- ☐ _____
- ☐ _____
- ☐ _____
- ☐ _____

HABIT TRACKER:

	M	T	W	Th	F	S	Su
	☐	☐	☐	☐	☐	☐	☐
	☐	☐	☐	☐	☐	☐	☐
	☐	☐	☐	☐	☐	☐	☐

NOTES:

9

10

11

12

3

4

Su
15

NOVEMBER 2020

PRIORITIES *(top 5):*

- []
- []
- []
- []
- []

TO DO *(action items):*

- []
- []
- []
- []
- []
- []
- []
- []
- []
- []

HABIT TRACKER:

	M	T	W	Th	F	S	S
	[]	[]	[]	[]	[]	[]	[]
	[]	[]	[]	[]	[]	[]	[]
	[]	[]	[]	[]	[]	[]	[]

NOTES:

16

17

18

19

20

21

Su 22

NOVEMBER 2020

PRIORITIES *(top 5):*

- []
- []
- []
- []
- []

TO DO *(action items):*

- []
- []
- []
- []
- []
- []
- []
- []
- []
- []

HABIT TRACKER:

	M	T	W	Th	F	S	Su
	☐	☐	☐	☐	☐	☐	☐
	☐	☐	☐	☐	☐	☐	☐
	☐	☐	☐	☐	☐	☐	☐

NOTES:

23

24

25

26

27

28

Su
29

NOTES

you should
just go
for it

DECEMBER 2020

SUNDAY	MONDAY	TUESDAY	WEDNESDAY
		1	2
6	7	8	9
13	14	15	16
20	21	22	23
27	28	29	30

THURSDAY	FRIDAY	SATURDAY	NOTES
3	4	5	_____

10	11	12	_____

17	18	19	_____

24	25	26	_____
	THANKSGIVING DAY		
31			

JANUARY 2021

S	M	T	W	Th	F	S
					1	2
3	4	5	6	7	8	9
10	11	12	13	14	15	16
17	18	19	20	21	22	23
24	25	26	27	28	29	30
31						

FEBRUARY 2021

S	M	T	W	Th	F	S
	1	2	3	4	5	6
7	8	9	10	11	12	13
14	15	16	17	18	19	20
21	22	23	24	25	26	27
28						

12

DECEMBER GOALS

20

LAST MONTH'S HIGH FIVES:

- _____
- _____
- _____
- _____
- _____

THIS MONTH'S GOALS:

WHAT'S THE MOTIVATION?

STEPS TO GET THERE:

THIS MONTH'S BUDGET

INCOME	PLANNED	ACTUAL
Earned		
Other Income		
Total Income		

EXPENSES	PLANNED	ACTUAL
Housing		
Utilities		
Groceries		
Transportation		
TOTAL EXPENDITURES		

SPENDING LOG

DATE	$	DESCRIPTION

TAL $ _____

DECEMBER 2020

PRIORITIES *(top 5):*

☐
☐
☐
☐
☐

TO DO *(action items):*

☐
☐
☐
☐
☐
☐
☐
☐
☐
☐

HABIT TRACKER:

	M	T	W	Th	F	S	Su
	☐	☐	☐	☐	☐	☐	☐
	☐	☐	☐	☐	☐	☐	☐
	☐	☐	☐	☐	☐	☐	☐

NOTES:

30

1

2

3

4

5

Su
6

DECEMBER 2020

PRIORITIES *(top 5):*

- []
- []
- []
- []
- []

TO DO *(action items):*

- []
- []
- []
- []
- []
- []
- []
- []
- []
- []

HABIT TRACKER:

	M	T	W	Th	F	S	Su
	☐	☐	☐	☐	☐	☐	☐
	☐	☐	☐	☐	☐	☐	☐
	☐	☐	☐	☐	☐	☐	☐

NOTES:

M
7

T
8

W
9

Th
10

F
11

Sa
12

Su
13

DECEMBER 2020

PRIORITIES *(top 5):*

☐ _____
☐ _____
☐ _____
☐ _____
☐ _____

TO DO *(action items):*

☐ _____
☐ _____
☐ _____
☐ _____
☐ _____
☐ _____
☐ _____
☐ _____
☐ _____
☐ _____

HABIT TRACKER:

	M	T	W	Th	F	S	Su
	☐	☐	☐	☐	☐	☐	☐
	☐	☐	☐	☐	☐	☐	☐
	☐	☐	☐	☐	☐	☐	☐

NOTES:

14

15

16

17

18

19

Su
20

DECEMBER 2020

PRIORITIES *(top 5):*

☐ _____

☐ _____

☐ _____

☐ _____

☐ _____

TO DO *(action items):*

☐ _____

☐ _____

☐ _____

☐ _____

☐ _____

☐ _____

☐ _____

☐ _____

☐ _____

☐ _____

HABIT TRACKER:

	M	T	W	Th	F	S	Su
	☐	☐	☐	☐	☐	☐	☐
	☐	☐	☐	☐	☐	☐	☐
	☐	☐	☐	☐	☐	☐	☐

NOTES:

21

22

23

24

25

26

Su
27

DECEMBER 2020

PRIORITIES *(top 5):*

- []
- []
- []
- []
- []

TO DO *(action items):*

- []
- []
- []
- []
- []
- []
- []
- []
- []
- []

HABIT TRACKER:

	M	T	W	Th	F	S	Su
	☐	☐	☐	☐	☐	☐	☐
	☐	☐	☐	☐	☐	☐	☐
	☐	☐	☐	☐	☐	☐	☐

NOTES:

28

29

30

31

1

2

Su
3

NOTES